THE UNIVERSE AND EYE

The Universe and Eye

Making Sense of the New Science

Text by Timothy Ferris
Illustrations by Ingram Pinn
Foreword by John Gribbin

In Association with
NewScientist

CHRONICLE BOOKS

San Francisco

First published in the United States in 1993 by Chronicle Books.

Text copyright © 1993 by Timothy Ferris
Illustrations copyright © 1993 by Ingram Pinn
Foreword copyright © 1993 by John Gribbin

Designed by Bernard Higton

ISBN: 0–8118–0300–7

Printed and bound in Portugal by Printer Portuguesa

Library of Congress Cataloging in Publication Data

Ferris, Timothy
 The universe and eye : making sense of the new science / Timothy
Ferris ; illustrations by Ingram Pinn.
 p. cm.
 Includes bibliographical references.
 ISBN 0–8118–0300–7
 1. Science—History—Popular works. 2. Technology—History-
-Popular works. 3. Science—Philosophy—Popular works.
4. Scientists—Popular works. I. Title.
Q126.F47 1993
500—dc20 92–25619
 CIP

Distributed in Canada by Raincoast Books,
112 East Third Avenue, Vancouver, B.C. V5T 1C8

10 9 8 7 6 5 4 3 2 1

Chronicle Books
275 Fifth Street
San Francisco, CA 94103

CONTENTS

INTRODUCTION

I was originally drawn to science by a sense of wonder at the Universe around us, a fascination for mysteries and a delight in the explanation of those puzzles. Reading *The Universe and Eye* reminds me of what it was like to be a little boy experiencing those feelings for the first time. From the "ripples in time" which mark the birth of the Universe in a Big Bang, and indicate the earliest development of galaxies like our Milky Way, to the molecule of life itself, DNA, science now seems to be on the edge of providing, once and for all, the answer to "life, the Universe and everything".

In the world of Timothy Ferris and Ingram Pinn, physicists talk with confidence of writing down, before the century is out, a single equation – one short enough to be put on a T-shirt – which will describe the workings of all the forces of nature. Genetic engineers not only interpret DNA but alter it, to create new forms of life, to endow old forms of life with new properties, and soon, it is hoped, to correct life-threatening inherited disorders.

But as Ferris recounts in part two of this book, "The Universe Within", scientists studying the complex way in which things interact in the Universe have discovered that there is much more going on than can be explained by the old mechanistic world view, the view of Newton and Descartes, which saw the Universe as like a gigantic clock, wound up by God and left to tick away its life inexorably. A lifetime ago, the quantum theory introduced chance and probability into our understanding of the subatomic world.

The behaviour of atoms, electrons and other subatomic particles literally obeys the rules of chance, more like

the outcome of the spin of a roulette wheel than the predictable ticking of a clock. And more recently physicists have come to appreciate that large numbers of atoms interacting with one another behave in ways that cannot be explained simply by adding up the properties of the individual atoms. The whole, we are constantly reminded as we turn these pages, is indeed greater than the sum of its parts, and under some circumstances even the swing of a simple pendulum (the essential component of that archetypal ticking clock) becomes unpredictable and chaotic. The study of chaos and complexity in the century to come will undoubtedly yield dramatic new insights into the workings of the Universe and ourselves.

And against all this background of excitement and change in science, Ferris points to the greatest mystery of all. It has taken just three hundred years, from the time of Newton, to arrive at a picture of the evolution of the Universe itself from a Big Bang which can be described using relatively simple equations and understood by the modest intellectual power of a human brain. Why should the Universe be so simple that it is intelligible to us at all? Why does it obey simple laws that we can represent by equations – why, in the catch phrase, is God a mathematician?

On the threshold of twenty-first-century science, there is no better way to get a feel for the excitement, strangeness and importance of these developments than through the insightful drawings of Ingram Pinn, and the pithy text of Timothy Ferris. This is the heart and soul of what science is about.

John Gribbin, 1993

Part One

OUT THERE

THE HANDWRITING OF GOD

It seems incredible that the inhabitants of one small planet orbiting an ordinary star could learn anything at all about the origin and structure of the entire Universe. Yet that is the story of observational cosmology in general, and of the cosmic microwave background in particular. In the 1940s the Russian-American physicist George Gamow and his colleagues noted that if the Universe began expanding in a high-energy state (the "big bang"), residual heat from that explosion should still suffuse the cosmos today, as a dim wash of photons observable in the microwave radio band. In 1965 two American radio astronomers, Arno Penzias and Robert Wilson, detected this background radiation. (Knowing nothing of the Gamow prediction, they happened upon their epochal discovery accidently, while checking a radio telescope for noise.) In 1989 the National Aeronautics and Space Administration (NASA) launched the Cosmic Background Explorer (COBE) satellite, which verified that the radiation displayed exactly the intensity and spectrum that would have been produced in the big bang.

As expected, the microwave background radiation proved to be isotropic and homogeneous – which is to say that it glows with pretty much the same intensity on all angular scales and in every direction. According to the most promising versions of the big bang theory, however, the radiation should when examined more closely begin to reveal traces of structure – high-density regions destined to grow, via gravitational force, into the clusters and superclusters of galaxies that dominate the Universe today. Pressing the COBE satellite's detectors to their limits, a team of astronomers at the University of California, Berkeley, announced in 1992 that they had found just such islands of density. They dubbed the structure "the handwriting of God." Their discovery lent support to theories proposing that the vast cosmic structures that today stretch across millions of light years of space originated as tiny quantum fluctuations in the very early Universe. Balloon-borne detectors are now being employed to map the early cosmic structure in greater detail. The information gained should make it possible to reconstruct important steps in cosmic evolution back to the first fraction of a second of time.

INFLATION AND THE BIG BANG

The inflationary hypothesis maintains that during the first fraction of a second of cosmic history the Universe expanded much more rapidly than it has ever since. So brief a cosmic hiccup might seem a small matter – inflation would have begun when the Universe was smaller than an atom, and ended when it was the size of a grapefruit – but it had startling consequences. Inflation implies that there may be many other universes, perhaps an infinite number of them, like so many bubbles in ocean foam. It also suggests that our Universe is enormous, far larger than the *observable* Universe, which is that part of the cosmos from which light has had time to reach our eyes. If the inflationary hypothesis survives test by observation (so far it has fared quite well) we shall have to consider that creation is even bigger and more complex than the Universe of a hundred thousand million galaxies, each home to a hundred thousand million stars, to which we have for the past sixty years been struggling to accommodate ourselves.

AN EYE ON THE HEAVENS

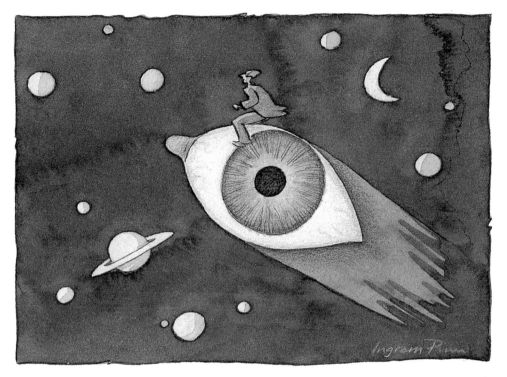

Everything we see belongs to the past. Because light travels quickly – 186,000 miles per second – we seldom notice the delay locally, but it becomes more important as we look out into space. Light from Jupiter takes 35 minutes to reach us when that giant planet is nearest to Earth, and nearly an hour when they are farthest apart. This affects the observed timing of eclipses of Jupiter's moons. As the Earth moves in its orbit around the Sun, it sometimes approaches Jupiter and sometimes recedes from it. If we are moving towards Jupiter, by the time the second of a pair of eclipses takes place, the light has less distance to travel and the eclipse therefore is seen early; when the Earth is moving away from Jupiter, the second of a pair of eclipses seems to be late. It was by observing such eclipses that the seventeenth-century Danish astronomer Olaus Römer first estimated the velocity of light.

We see galaxies as they looked millions of years ago, and quasars – the furiously burning cores of young galaxies – as they were billions of years in the past. The whole tapestry of cosmic history awaits our inspection. All we have to do to see it better is to build more powerful telescopes.

CLIMATE AND SOLAR VARIATION

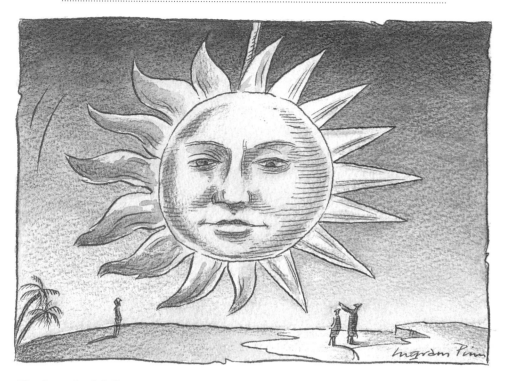

The Sun, thankfully, is a constant star, but it does go through changes that affect the environment here on Earth. Especially dramatic are solar flares, which spew out high-energy particles that can alter the Earth's magnetic field. On March 10, 1989, a magnetic storm occasioned by a solar flare lit up night skies from the poles to Bolivia and the Florida Keys and blew out electrical power across most of Quebec. The Sun's brightness varies by only fractions of one per cent, but scientists agree that these variations can modify the Earth's climate. The Little Ice Age of 1450–1850, when snow capped the mountains of Ethiopia and the Thames froze over, coincided with a period of virtually no sunspots.

But the Earth's climate is far too complex for such simple connections to tell more than a part of the story, and scientists are studying tree rings and sediments that record sunspot cycles to learn more. One reassuring result, from a study of Precambrian glacial melts in south Australia, indicates that sunspot cycles were the same 680 million years ago as they are today. As John Keats wrote, "Bright star, would I were steadfast as thou art ...".

NOCTILUCENT CLOUDS

Noctilucent ("night-bright") clouds are high – 50 miles high, higher than the atmosphere was once thought to extend – and mysterious. Best observed from northern latitudes when the rays of the Sun highlight them against the night sky from below the horizon, they are thought to be composed of ice crystals. The ice in turn may form on grains of dust blasted into the upper atmosphere by volcanic activity like the 1991 eruption of Mount Pinatubo in the Philippines, which produced spectacular red sunsets around the world for more than a year thereafter. Studies by cosmonauts aboard the Soviet Salyut-4 space station indicate that volcanic dust is found at all latitudes, but that ice tends to form on the dust only near the poles, producing the curious glow of the noctilucent clouds. Space shuttle missions are being re-navigated to avoid astronauts encountering the clouds, which NASA engineers fear could make the shuttle skid off course during re-entry. Here, as in so many other instances, the view from space informs us that we all share one small world.

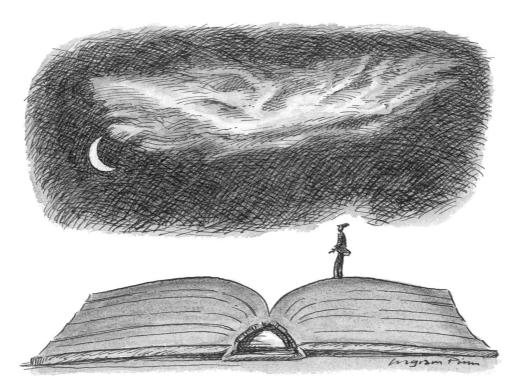

SNOWBALLS FROM SPACE

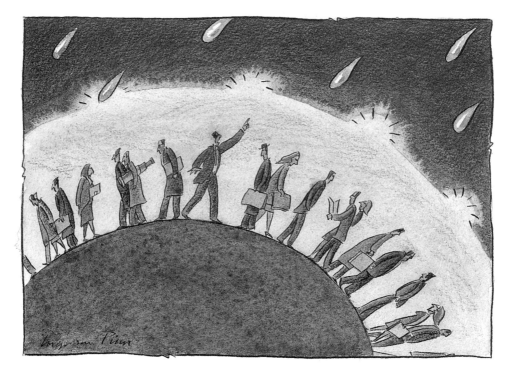

The American geophysicist Louis Frank discovered in 1981 that the Earth's upper atmosphere appears to be punctured by thousands of little holes. He attributed them to the impacts of icy, comet-like objects, which, he theorized, vaporized to produce the oceans. The jury is out on that theory, but many scientists speculate that comets may have bequeathed our planet not only its oceans, but life itself. Comets are rich in organic molecules. When the Solar System was young there were many more comets — enough, perhaps, to have soaked local space with organic molecules, flooding Earth with a fertile rain from which the first living organisms arose.

If such theories of comet-assisted genesis stand up, they may serve to rehabilitate the rather shabby reputation of comets, long ridiculed by astronomers as "celestial vermin" and "the nearest thing to nothing that something can be and still be something." In future we might instead regard comets with new respect, as white-bearded ambassadors of the celestial species to which all Earth's creatures owe their existence.

COMET CATASTROPHES

Evidently comets are agents not only of life but of death. It seems that something (a companion star, perhaps) periodically sends squadrons of comets plunging into the inner Solar System, where they subject the Earth to a mighty pelting. Such is the prevalent explanation of what caused the massive extinction events that dot the fossil record, recording grim episodes when as many as nine-tenths of all living species disappeared more or less overnight (that is, in terms of geological time, over thousands rather than millions of years).

If so, comets present us with a morality tale about how the same event can seem very different from two points of view. The catastrophe that wiped out the dinosaurs looks relatively cheerful. It made way for our ancestors to evolve, and thus may be said to have granted us dominion over our planet. But now that we rule, we seek no further visitations by celestial doom. An alarmed NASA is thinking of arming missiles to push threatening comets off course, lest the world be transformed anew.

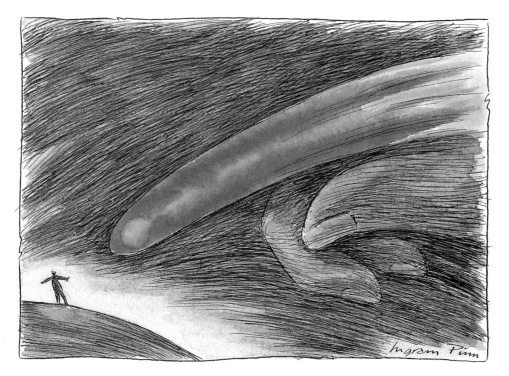

SUPERNOVAE

Giant stars live fast and die young, burning up their fuel in a hundred million years or less and then exploding, with titanic force, as supernovae. Supernovae are important to galactic ecology, for it is here that atoms of heavy elements are forged and then blasted into space, to be incorporated into latter-day stars and planets. Every scrap of gold on Earth originated in giant stars that exploded before the Sun was born.

We owe an intellectual debt to supernovae as well. Supernovae observed by the Renaissance astronomers Tycho Brahe, Johannes Kepler and Galileo Galilei helped encourage them to discard Aristotle's premise that the heavens are made of an immutable substance different from the elements found on Earth – a realization that inaugurated the science of astrophysics. There are even tantalizing clues that a supernova in the southern constellation of Vela, casting long shadows across the dusky planes of Sumeria, somehow spurred on the development of intensive agriculture and the written word. (The Sumerians identified that supernova with *Enki*, the god of writing and farming.)

This drawing illustrates the four stages in the career of a giant star destined to explode – as a protostar condensing from interstellar gas, a healthy blue giant star, a red giant and, finally, a supernova.

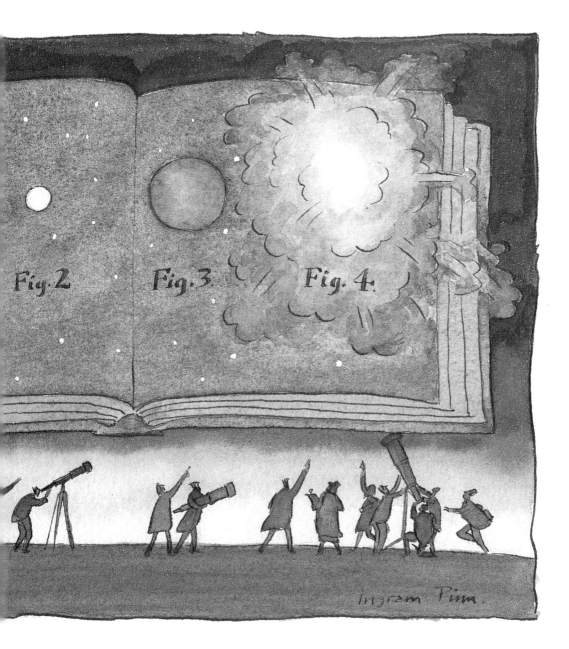

Fig. 2. Fig. 3. Fig. 4.

Ingram Pinn.

VALUABLE ASTEROIDS

Nothing seems more worthless than an asteroid, a lumpy hunk of rock adrift in space, unlikely to attract general attention unless one threatens to hit Earth and destroy something valuable. But many asteroids are rich in metals – in platinum-group metals, for instance, worth more than $20,000 per pound – and in other precious substances, including diamonds. When we begin to run out of precious metals here on Earth, asteroids could become valuable enough to be worth mining. We may then see gold rush-style boom towns springing up out past the orbit of Mars, with claim-jumpers contesting mineral rights on space boulders.

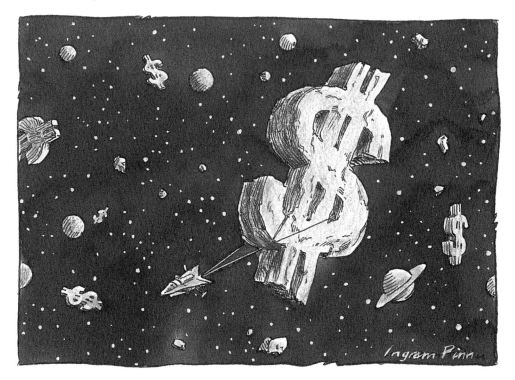

SUSTAINING LIFE IN SPACE

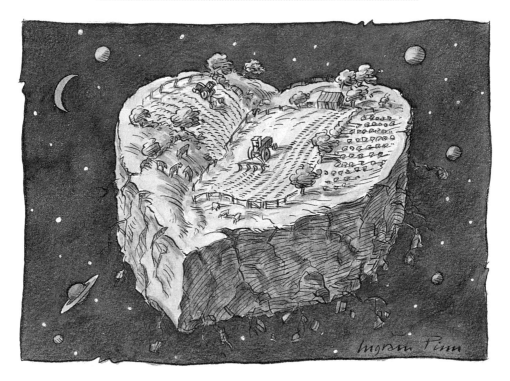

Everything we are and everything we have ever touched – seawater, sunflowers, the rich loam of a Tuscan farm – is made of atoms that once were adrift among the stars. These atoms are found on neighboring planets as well, so in principle it should be possible to rearrange them in such a way that Mars, say, could be given a breathable atmosphere and become a Kansas-style place of thunderclouds and cornfields.

But the formidable technological issues invoked by terraforming, as this prospect is called, are matched by the ethical concerns it raises. If we take care of our own planet, we might in good faith endeavor to seed barren planets with earthly life. If, instead, we resort to terraforming as a means of escaping ecological disaster at home, that bad faith effort will almost certainly be doomed. Spaceflight cannot solve the population problem – there will never be enough spaceships for that – and in any event there's little point in colonizing another world just to muck it up. The question, baldly put, is whether our species is good enough to *deserve* a new world.

MOON AND EARTH

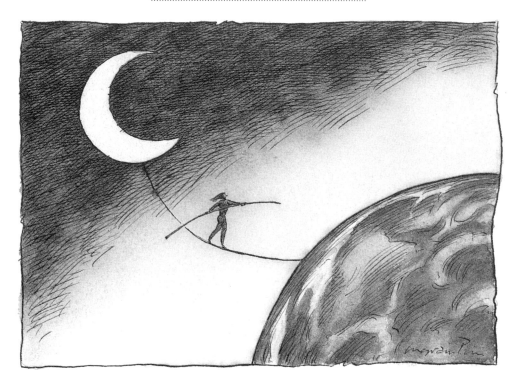

"Man has invented his doom / First step was touching the Moon," wrote Bob Dylan, and while one might take issue with his sentiment, he is nevertheless one of the few writers to have appreciated how much our impression of the Moon has changed since men set foot there.

The Moon's metamorphosis began in 1609, when Galileo first trained a telescope on the sky and immediately found, from the sight of the Moon's craters and craggy mountains, that he was looking not at a wafer made of Aristotelian ether but a sovereign world.

Galileo's contemporary Kepler was soon at work writing a science fiction account of a lunar mission, and we've been on our way ever since, for where the imagination goes, Man soon follows.

The tightrope in this drawing may be real some day. It's theoretically possible to lower a tether from a satellite to the ground, and use it to run an elevator service carrying people and cargo into orbit. Space tethers may provide a way to orbit the imposing payloads we will need if we are going to establish large space stations, and colonize the once-unapproachable Moon.

SPACE EXPLORATION

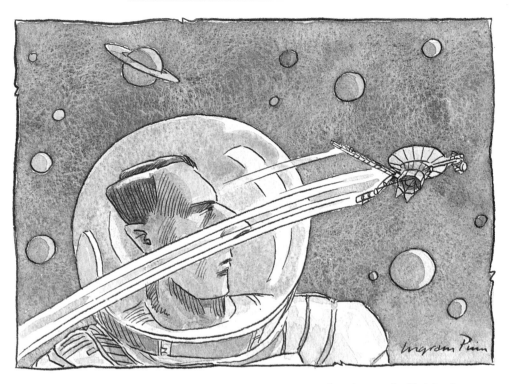

This image of an astronaut watching a fleet-footed Voyager space probe disappear into the depths of space captures the sad dynamic of the American and Russian space programs. Both countries spend the lion's share of their space budgets on plodding and costly manned programs, while more cost-effective science-oriented campaigns go begging.

Behind the conflict lie two competing views of humanity's place in the Universe. The unmanned program represents the view, embodied in the sciences, that we have a lot to learn about nature. The manned program embodies an older view, one that assumes that we already know quite enough (all that God intended us to know, religious fundamentalists would say) and that our proper role is to make practical use of our knowledge. It is because the latter view has prevailed in political circles that our space programs, by and large, remain mired in low Earth orbit.

SPECTACLES FOR HUBBLE

The Hubble Space Telescope debacle opened the eyes of the public to the fact that NASA, once an emblem of technological excellence, had degenerated into an arteriosclerotic bureaucracy less concerned with how its missions would fly in space than with how they would fare in the halls of Congress.

The space agency made three howling blunders with Hubble. First, it permitted the same corporation that made the main mirror to also test it. Second, it neglected to check the optics system of the fully assembled telescope. And then, once Hubble was in orbit and it became evident that the mirror had been ground incorrectly, it attempted to justify its prior oversights by claiming that to have tested the mirror in the first place would have cost millions of dollars. (As every amateur telescope maker in the world knows, an analysis adequate to have detected so glaring a flaw in a mirror could have been conducted with nothing but a candle, a razor blade and a saucer of water.)

The Hubble debacle gave a black eye to Big Science, proving the point of critics who had argued that NASA should have built a succession of smaller orbiting telescopes, rather than putting all its eggs in one expensive (read vote-getting) instrument. The White House responded to the crisis by increasing NASA's funding.

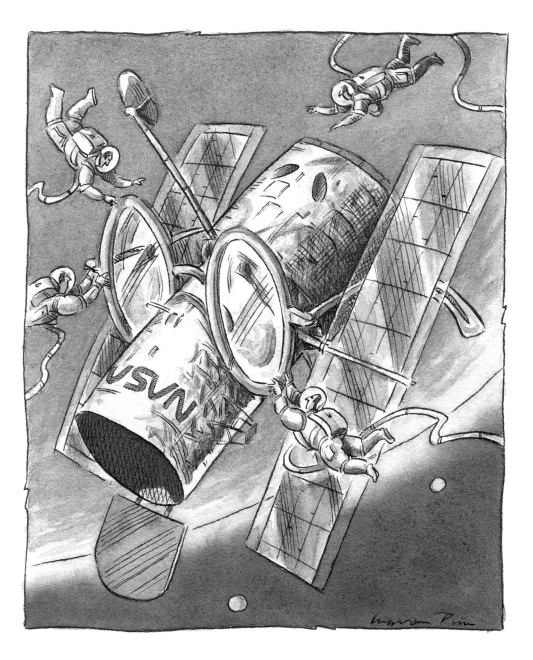

INTERSTELLAR TRAVEL

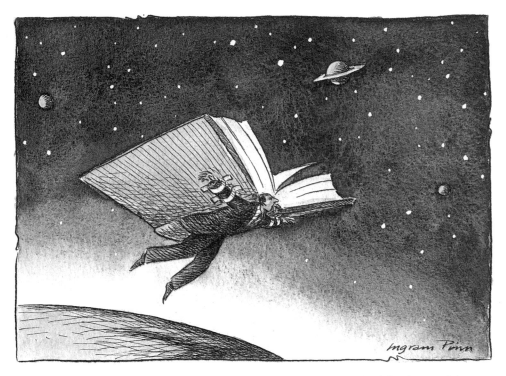

Interstellar travel is routine in the pages of science fiction tales, but most of the scientists and engineers who have studied the question are pessimistic about the prospect of flying to the stars. The cost in propellant, they note, might well exceed the total current energy output of the industrialized world. A starship at speed would have to deflect or evade every tiny interstellar dust grain, each of which would pack the wallop of a cannon ball. These and many other high hurdles lie between here and a real-world realization of *Star Trek*.

Still, one wonders. A haunting invitation is contained in the special theory of relativity, which shows that the passage of time aboard a starship moving at nearly the velocity of light would be so much slower than here on Earth that astronauts could travel vast distances in manageable periods. If their ship could maintain a steady acceleration that reproduced the force of Earth's gravity, they could sail all the way to the Andromeda galaxy in less than thirty years of on-board time. But they could never return. By the time they landed in Andromeda, two million years would have expired back home.

TIME TRAVEL

Theorists tilling the fertile gardens of Albert Einstein's general theory of relativity tell us that time travel may indeed be possible – not out here in the ordinary world, where journeys into the past would violate fundamental laws of science and logic, but in the netherworld that lurks within black holes. There, on the slopes of steeply curving space, one might find "spacetime loops" spun in such a fashion that an astronaut who dove into one would emerge in the past.

The American physicist J. Richard Gott III, working with a conjecture first published by Kip Thorne, described such a scenario. "If you fell into a black hole you'd look for a closed time–like curve, because entering one would forestall your doom," Gott remarked. "If you made your way to an entrance you'd see, say, eleven copies of yourself. The first version of yourself might say, 'I've been around once,' the second, 'I've been around twice,' and so on. You plunge into the loop, fly around it, and return to see yourself entering the black hole. Wanting to be helpful, you call out, 'I've been around once.' You're now the first image of yourself that you saw when you entered. After another trip, again encountering your original self, you call out, 'I've been around twice.' And so on, until, after eleven times around, you leave the loop, only to be killed a short time later when you crash into the singularity at the center of the black hole."

Part Two

THE UNIVERSE WITHIN

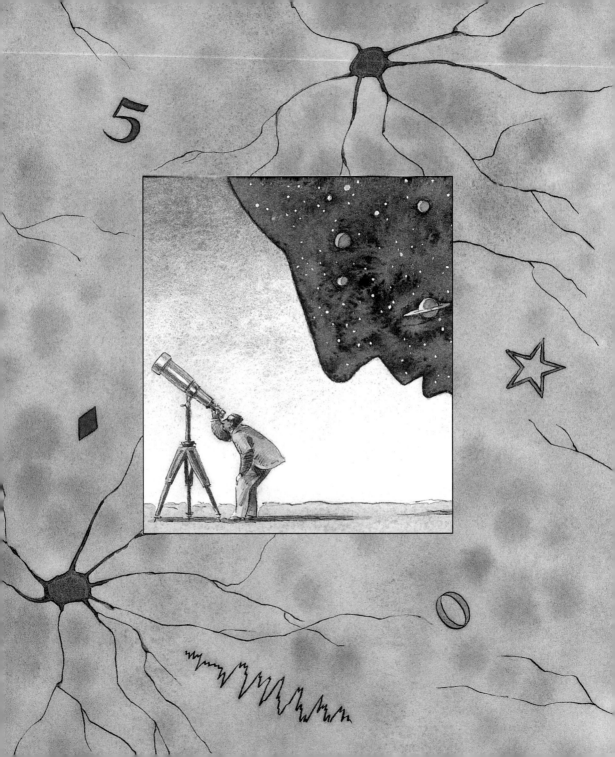

NOSTRADAMUS - HOT AIR?

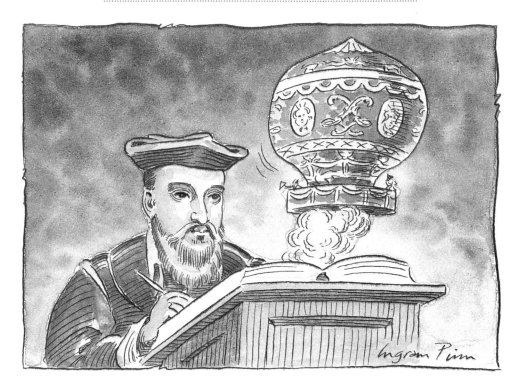

With regard to truth there are three sorts of propositions: those that are true, those that are false, and those that are too vague to be true *or* false. Scientists have little use for the third variety – propositions that, as one physicist put it, are "not even not true" – but palmists and astrologers couldn't get along without them. The sixteenth-century seer Nostradamus knew how to play this particular violin very well indeed. His prophecies are so murky that his interpreters still differ on whether key passages predict the AIDs pandemic, earthquakes in California, or the invention of the hot-air balloon.

What distinguishes great prognosticators like Nostradamus or the Oracle at Delphi from the lesser lights of pseudoscience is not that they are more accurate but that they are more evocative. Their pronouncements touch deep chords in the human psyche. In this sense prophecy, like poetry can teach us about ourselves. Provided, of course, that we abandon the notion that it predicts anything.

Inner and Outer Space

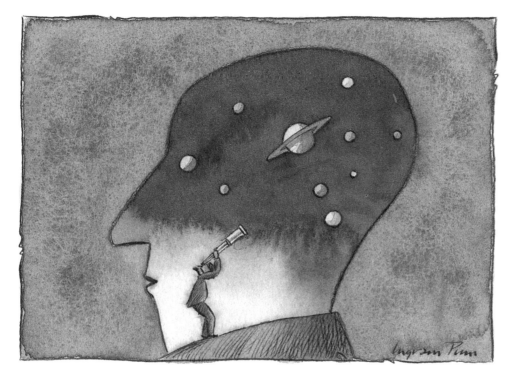

All that we can ever comprehend of the Universe must reside within our minds. That's the human condition, and the predicament of every other intelligent being in the Universe, too. You may be a city-sized squid so smart that you can compose a symphony and balance the galactic budget before breakfast, but your conception of the Universe will of necessity always dwell within your mind.

This means, of course, that one's model of the Universe is smaller – lesser, in some sense – than the reality.

But that's not such a bad thing. Models by definition are lesser than the reality they represent, and for models of the Universe this constraint obviously must be particularly stringent.

The amazing thing is not that mental models of nature are flawed or diminutive, but that they work at all. The equations of Kepler, Newton, and Einstein really do account for the trajectories of the Moon and the Andromeda galaxy. Nobody knows why this should be so.

BREAKDOWN OF THE MECHANICAL VIEW OF THE UNIVERSE

The mechanical view of nature, beautifully quantified in Newton's laws, is based on three precepts. The first is strict causation: every effect results from a cause. The second is precision: in principle, any physical process can be measured to an arbitrarily high degree of accuracy. The third is objectivity: each event can be described in one and only one entirely factual way, upon which all observers everywhere can agree.

Quantum physics reveals that all three suppositions fail when we interrogate nature on the subatomic scale. There, partly because one cannot even in principle keep track of trillions of subatomic particles, strict causation is replaced by the statistics of probability. Moreover, owing to Werner Heisenberg's uncertainty principle, all observations are seen to be afflicted with a small but irreducible degree of imprecision. And classical objectivity gives way to the realization that the conduct of the experimenter can affect the outcome of the experiment.

Perhaps because it was so strenuously resisted by Einstein, who was revered as both a scientist and a philosopher, the fall of the Newtonian clockwork model of nature is sometimes described in terms of lamentation more suitable to the end of the world. But Newtonian mechanics still works fine on the everyday scale, just as quantum mechanics works on the small scale and general relativity on the large scale. The task now facing science is to find an over-arching set of laws that embraces all three realms. What it will have to say about causation, precision and objectivity remains to be seen.

INFORMATION THEORY

It might be said, borrowing lines from Shakespeare's *As You Like It*, that science:

> *Finds tongues in trees, books in the running brooks,*
> *Sermons in stones, and good in every thing.*

Which is to maintain that from a scientific standpoint everything has value because everything contains information. This notion may sound cold at first glance, but in practice it has worked to ennoble the world. Thanks to science, humble rocks and inconspicuous microorganisms now teach us about the history of life, while every anonymous wave is a lesson in hydrodynamics, each fallen leaf a botany textbook.

Exploring this viewpoint further, some philosophers of science now consider that the ultimate subject of scientific inquiry may be not space and time and matter and energy, but information. They are encouraged by the advent of computers, which by digitizing information – that is, turning it into "bits" – make themselves useful in a wide variety of applications, from guiding spacecraft and diagnosing disease to designing buildings and composing music. Perhaps the sciences, similarly, could be unified were each analyzed in terms of information theory – as involving data input (observation), analysis (thought), and output (theories and the design of new experiments).

Not that all would thus be rendered starkly logical, for the mysterious allure of nature remains unquantifiable even if the amount of data that produces it can be measured. Science like art arises from a love of nature, not just a desire to exploit her. Francis Crick recalls hearing James Watson describe their discovery of the structure of the DNA molecule. The setting was an evening meeting of the Hardy Club, whose practice was to ply the speaker with as much alcohol as possible before the talk. Crick writes that a somewhat unsteady Watson did fairly well at first, "but when he came to sum up he was quite overcome and at a loss for words. He gazed at the model, slightly bleary-eyed. All he could manage to say was 'It's so beautiful, you see, so beautiful!'

"But then, of course," adds Crick, "it was."

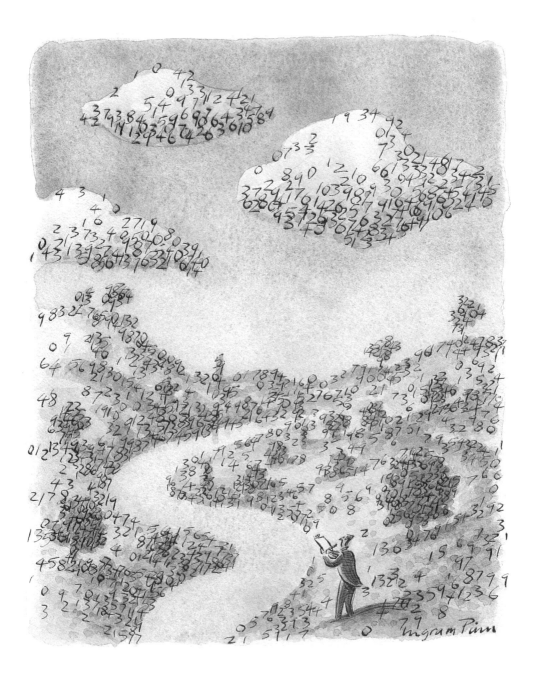

PARAPSYCHOLOGY AND PSYCHIC PHENOMENA

Devotees of the paranormal disparage scientists as narrow-minded, unimaginative conformists who, having been taught a set of standard answers to nature's riddles, thereafter turn a blind eye to evidence of extrasensory perception, flying saucers, reincarnation and other phenomena they can't explain. Yet without the unexplained, scientists would soon be out of a job.

The real difference is that scientists enjoy a greater tolerance for ambiguity than do pseudoscientists. The scientist, confronted with reports of lights in the sky or things that go bump in the night, says, "I don't know what they are." The pseudoscientist cannot tolerate this state of affairs. He knows, all right: they're alien starships, or evidence of life after death. But it is useless to grasp at extreme hypotheses to explain every anecdotal report. As Newton wrote, "To tell us that every species of things is endowed with an occult specific quality by which it acts and produces manifest effects, is to tell us nothing."

PHYSICS AND PSYCHICS

The wind that blows down the psychic house of cards is powered not by scientific authority but by scientific experiment. Thousands of experiments on extrasensory perception have been conducted, and their inescapable conclusion as to mind reading is that, as Gertrude Stein said of Oakland, California, there's no there there.

Everyday experience suggests not only that we cannot read one another's minds, but that we quite often have trouble understanding what is said to us in plain, straightforward language. Nearly half the mail authors receive has to do, not with something they wrote, but with something the correspondent thinks they wrote, so strong is our tendency to read our own thoughts onto the printed page. We might be better off in an ESP world, but it's not the world we inhabit.

Mathematicians are fond of saying that mathematics is the key to it all. "God is a mathematician," declared the mathematician Gottfried Wilhelm von Leibniz. But while it is unquestionably true that mathematics works, it remains a mystery just why this should be so. Unexplained is the curious fact that rules of number developed here on Earth – in the work of ancient Egyptian rope-stretchers surveying the Nile, and of college professors today who use computers to prove theorems beyond the reach of human calculation – should also enable us to generate nuclear power and calculate the mass of the Magellanic Clouds. As the Hungarian mathematician Eugene Paul Wigner wrote, "The miracle of the appropriateness of the language of mathematics for the formulation of the laws of physics is a wonderful gift which we neither understand nor deserve."

Illogical is the interaction of game players' minds with the inflexible laws of mathematical probability. Most of us believe, for instance, in winning streaks, yet mathematicians studying sports records conclude that there is no such thing as a winning streak. This is true even in player-influenced games such as cricket and basketball, where we might expect that players who believe in winning streaks might do better when they think they're on a streak. Even more illusory, therefore, must be the wide-spread supposition that winning streaks exist in games like roulette, where the player cannot influence the outcome.

Yet few of us accept these facts. Except for professional gamblers, who prosper at the gaming tables but tend to find them boring (it's all so predictable if you know the odds), most of us prefer to go on believing in the magical notion that each can be visited by intervals of good luck. And that is why the owners of the Flamingo, the first big casino to open in Las Vegas, realized a $10 billion profit on a $6 million investment.

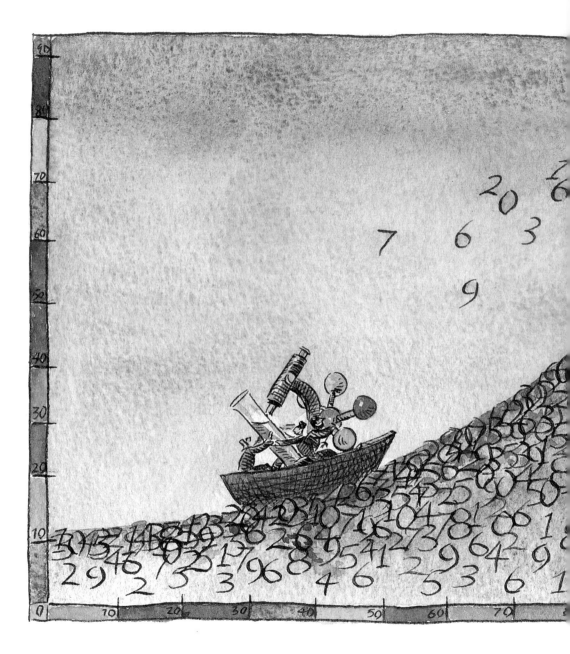

STATISTICS AND CHANCE

Let us now praise random chance, author of the constellations, actuarial tables, and us. When science in the arrogance of its prideful youth assumed that strict causation ruled the Universe, making every event from the explosion of a star to the composition of Ludwig van Beethoven's late quartets in principle predictable by science, probability was thought to be but the mask of temporary ignorance. Once we know all the facts, it was said, we can forecast the outcome of every phenomenon. But now we understand, thanks to the discovery of the Heisenberg uncertainty principle and the emerging sciences of complexity, that we can never know all the facts. A fundamental fuzziness clouds every prediction in the Universe.

This situation is not only inevitable, but potentially creative. Random chance, essential to the evolution of every living thing, can be used even to design machines and electronic circuits; engineering firms are beginning to realize healthy profits by programming chance into their research and development efforts. God is portrayed in this conception not as a clock maker but as a creative artist, whose creations, like our own, can be known only in the fullness of future time.

EUPHEMISMS OF WAR

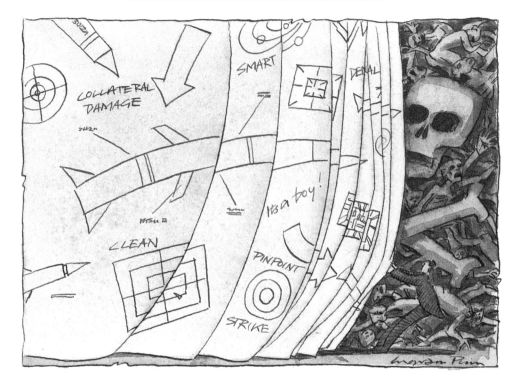

By using words we can lie not only to one another but to ourselves; that's one of the prices we pay for language. The less appetizing the reality, the more inclined we are to resort to euphemisms, thus comforting ourselves by denying ourselves the truth. It would hardly be seemly for weapons designers, say, to describe their job as "finding new ways to blow the arms and legs off children," and so conversation in such circles tends toward talk of "antipersonnel devices," the use of which in a "conflict" necessarily results in "collateral damage."

Years ago Einstein declared that "to kill in war is not a whit better than to commit ordinary murder." How often today do we hear such unambiguous sentiments, so bluntly stated? It seems we can afford an endless profusion of deadly weapons, but not plain talk about what they do.

THE BLACK BOX OF THE MIND

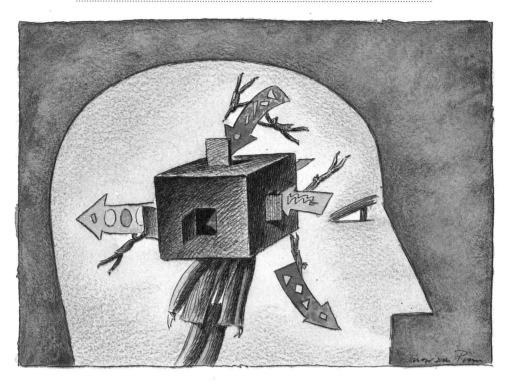

Cognitive psychologists have sought to model the mind as a "black box," meaning that we are better off studying what goes into the brain and comes out of it than worrying overmuch about what's inside. But this metaphor, while useful in some regards, tends to deflect attention from the marvelous complexity of the brain, just now coming within the grasp of scientific research. It also promotes the faintly arrogant attitude that one person can grasp everything important about another person simply by analyzing his or her behavior. If taken to heart (to borrow another metaphor) the black box model leads to the joke about the two behavioral psychologists who, after making love for the first time, say to each other, "It was good for you. Was it good for me, too?"

Part Three

TECHNOLOGY AND THE ENVIRONMENT

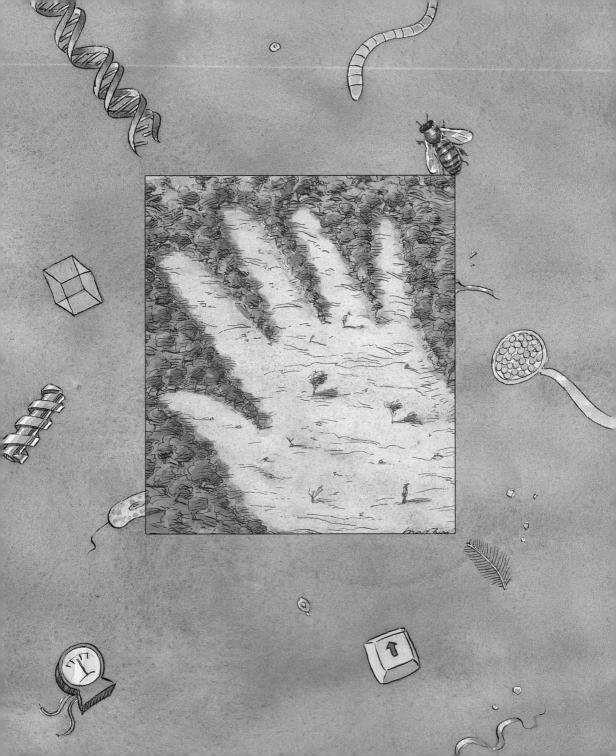

Nanotechnology

In the age of steamships and skyscrapers engineers learned to think big. Now, in the age of the microchip and genetic engineering, they're learning to think small. *Very* small. Researchers involved in nanotechnology (from *nanos*, Greek for dwarf) dream of constructing powerful computers smaller than a living cell and machines smaller than a virus. Molecular-scale "nanosubs" assembled from individual atoms could clear clogged arteries, break down cancer-causing oncogenes, clean up oil spills, or comb the upper atmosphere for pollutants. The applications are almost limitless; as the American physicist Richard Feynman put it, in a 1959 talk credited with sparking interest in nano-technology, "There's room at the bottom."

Preliminary work indicates that nanotechnology may indeed be feasible. Scientists at the University of California, Berkeley, have built a working motor smaller in diameter than a human hair, equipped with rotating arms the size of blood cells. Researchers at IBM have managed to manipulate individual xenon atoms. (They made them spell "IBM.") But many difficulties remain. Molecules are floppy – to press them into service as bearings and gear teeth will require the skills of a lathe operator combined with those of a weaver – and heat makes them jitter more violently than an auto-assembly plant in an earthquake.

Perhaps here, as has been the case in aeronautics, navigation, remote sensing and many other varieties of engineering, answers will be found by studying how nature does the job. Living cells, after all, are equipped with simple nanomachines (proteins) controlled by computer-like molecules (DNA). In an embryo they build from the bottom up, starting with a single cell that replicates and differentiates until the result is a mushroom, a dolphin or a human being. Our grandchildren may employ similar technology to grow computers, surgical implements, apartment buildings, and spaceships.

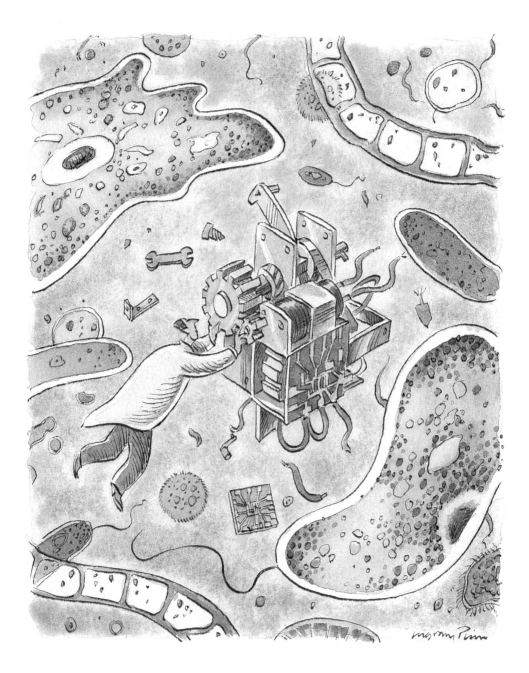

ELECTROMAGNETIC FIELDS

The American physicist Robert Wilson, working in the 1930s at the Berkeley Radiation Laboratory on one of the world's first particle accelerators, repeatedly exposed himself to powerful electromagnetic fields. "Descending into the magnetic field region," he recalls, "you ... were aware of the beautiful optical effects not unlike fireworks, evidently due to currents induced in the optic nerve. When a calculation showed that the currents induced in the brain were comparable to or even greater than those used in shock therapy, we decided to turn off the magnet before going down into the pit." It had dawned on Wilson and his colleagues that the brain is itself an electromagnetic device, and they wondered whether its functioning might be influenced by ambient electromagnetic fields.

Today we're still wondering. Anecdotal reports linking high-tension wires and electrical stations to cancer have not usually stood up well under closer scrutiny. But in 1992 researchers announced that they had found magnetic crystals in the human brain. Until the function of these crystals is ascertained, surely it would be wise to continue investigating possible ill effects of exposure to electromagnetic fields generated by high-tension power lines, television sets and computer monitors.

LIBRARIES ON DISC

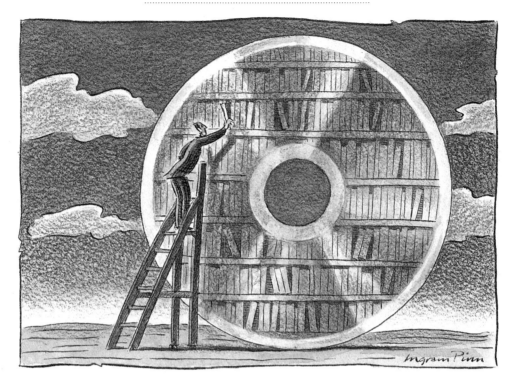

Television has dealt literacy a terrible blow. Ironically, it may be another electronic device, the computer, that helps to reverse the damage. Like TV, computers appeal to young people. Unlike TV, they are interactive, not passive. If the contents of, say, a million books can be digitized, it just may be possible to bring substantial portions of our youth back into the world of literature. The bait is convenience. A student researching a paper on the political career of the poet Su Tung-p'o could use a computer and modem to run Boolean searches through shelves full of books in distant libraries – looking for volumes in which, say, Su's name coincides with "governor," and "Hangchow" – then download the relevant chapters and take them home on a disc. (Soon the computer itself will be no larger than a book, and will link to the wider world through a wireless cellular modem.)

Electronic books are different from paper books in some respects – they can be checked out of libraries and never returned, can be duplicated endlessly, can speed around the world at the velocity of light – and they can add various bells and whistles to reading. (You can both read a poem and hear the poet read it aloud.) But their ultimate contribution may be to reintroduce students to the old-fashioned merits of words in books.

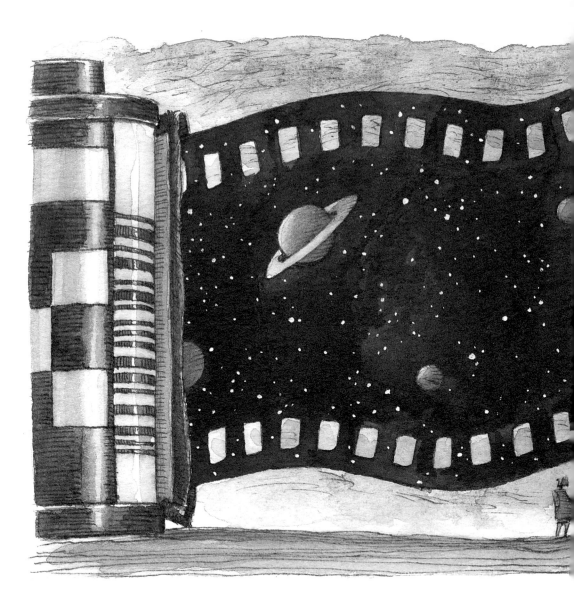

ASTROPHOTOGRAPHY

Amateur astronomers once contended with professionals for the honor of making important advances. William Herschel was an amateur when he discovered the planet Uranus in 1781. William Parsons, the third Earl of Rosse, discovered the spiral "nebulae" – what we today call galaxies – from his ancestral estate, Birr Castle, through a 72-inch telescope that was then the largest in the world. Another amateur, William Huggins, fitted a spectroscope to the telescope at his private observatory on Upper Tulse Hill in London and identified iron, sodium, calcium, magnesium and bismuth in the spectra of the bright stars Aldebaran and Betelgeuse, establishing that stars are made of the same elements found on Earth and in the Sun.

Twentieth-century astronomy, however, has been dominated by professionals. Using giant telescopes that cost millions they studied distant galaxies, while amateurs were relegated, for the most part, to charting the brightness of variable stars and making drawings of the Moon, Mars and Saturn's rings.

Now the amateurs are getting back into the act. Advances in telescope design have put large-aperture instruments within the financial grasp of many hobbyists; reflecting telescopes with light-gathering mirrors 18 and 20 inches in diameter, once a rarity, are now commonplace at amateur gatherings. Fast new photographic emulsions have come on the market, making it easier to take full-color photographs of galaxies and nebulae that show detail far beyond the reach of the human eye. And the invention of charge-coupled devices (CCDs), ten times as sensitive as photographic film, have greatly improved the capacity of all telescopes. Today an amateur using a home-made telescope hooked up to a CCD camera and a personal computer – a rig that typically costs no more than a decent motorcycle – can plumb the depths of space to a range that until a decade or so ago was attainable solely at the legendary Palomar Observatory in California.

ARTIFICIAL INTELLIGENCE

One difficulty in trying to understand intelligence is that we have but a single example of it, and science is not very good at investigating phenomena of which it has but a single example. Certainly we can learn about ourselves by studying apes and chimpanzees, but their lack of a rich spoken language puts sharp limits on similarities between their intelligence and our own. A message from an extraterrestrial intelligence would help. By providing the missing perspective, its content might well tell us more about ourselves than about the extraterrestrials. Until we receive such a message, the best prospect may be artificial intelligence. When might we expect to have a machine as intelligent as a human being?

Not for a long time, if ever. The human brain is far more complicated than any computer, and in any event the benchmark to be attained by some super-microchip of the future is to match the performance, not of an isolated human brain, but of a brain reared in a society comprising many humans. That's a pretty steep learning curve. To achieve intelligence a computer must not only have innate potential, but must somehow realize that potential through complex interactions with other computers. Perhaps this will happen, someday, and Earth will be home to two intelligent

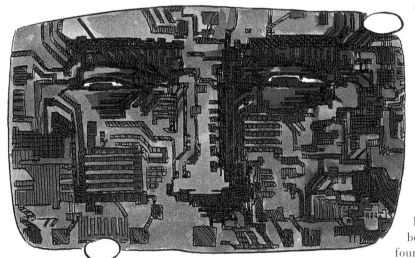

species, one based on carbon and the other on silicon. But probably not soon. It took humans more than a million years to fashion human society, and we started with an exquisite neural apparatus that had already benefitted from four billion years of evolution. And we're not all that smart, yet, either.

ROBOT SERVANTS

Back when computers first came on the scene, scientists and sci-fi writers alike assumed that they would soon be put to work as the electronic brains of household robots. It didn't work out that way. Computers have proved adept at handling abstract challenges like flying spaceships, playing chess, and solving quadratic equations, but housework is too hard.

It seems that scientists at first underrated the amount of brain power required to carry out physical acts. More recently they have begun to appreciate that actions are governed by higher-brain centers, just as is abstract thought, and are dauntingly complex. Speech itself, arguably the hallmark of human intelligence, appears to be processed by the brain as but one among many complex sequences of actions - one that may have arisen in response to selection pressures involving the throwing of spears and stones. Janitors, house movers, athletes and many other practitioners of what academics once looked down upon as merely physical tasks are accomplishing what no computer - not even the giant mainframe machines that can beat college professors at chess - has yet begun to master.

VIRTUAL REALITY

Virtual reality (VR) is an interface that takes you *inside* a world created (or replicated) by a computer. You don a headpiece equipped with stereo-vision color monitors and a sensor that keeps track of your head movements. Turn around and you see what's behind you; look up and down and you see what lies above and below. Put on a VR glove – as in the illustration – and you can manipulate objects.

VR has applications ranging from exercise (there's already a flying bicycle, modeled after the one in the film *ET*) to marketing (teenagers are invited to shop in VR malls) to pornography (with ethicists discussing the prospect of sexual encounters between people thousands of miles apart who have never met and may not even look the way they choose to present themselves via VR). It also has the potential to democratize the space program. Once VR is up and running on the average home computer, a space probe imaging the canyons of Mars or the icebergs of Ganymede will be transmitting back, not just pictures, but entire environments that millions can explore. Not just a few intrepid astronauts but everybody could "be there."

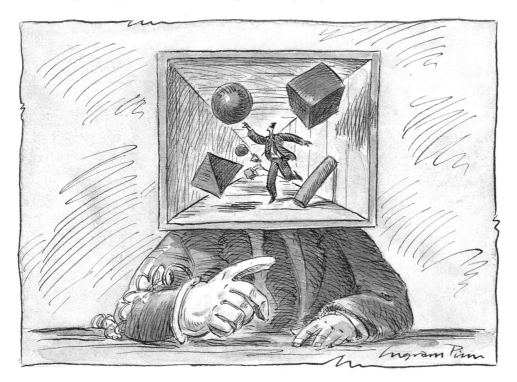

COMPUTER CRIME

As computers insinuate themselves into virtually every realm of human activity – there is a computer for every four persons in the industrialized world these days – they bring with them a rising incidence of computer crime. Best known are the computer viruses – hidden programs that stow away aboard conventional computer files, spreading around the world as files move through communications networks. These range from the relatively benign "Yankee Doodle" virus, which instructs computers to play the anthem of the American Revolution every afternoon at five, to the malignant "Dark Avenger," a Bulgarian virus that crippled computers in Britain, Russia, Czechoslovakia, Poland, Hungary, and Mongolia.

What most worries electronic security experts are not overt acts of mischief such as sabotage, extortion and fax graffiti attacks, but sly computer crimes so cleverly programmed that they are never discovered. In one pioneering effort, a hacker instructed a computer involved in calculating credit card interest to round off all fractions of a penny downward, and credit them to an account set up in the perpetrator's name. Since nobody was robbed of more than a penny at a time, nobody noticed, and the crime almost escaped detection. One wonders how many other computer crimes, slightly more clever still, have never come to light.

CHERNOBYL

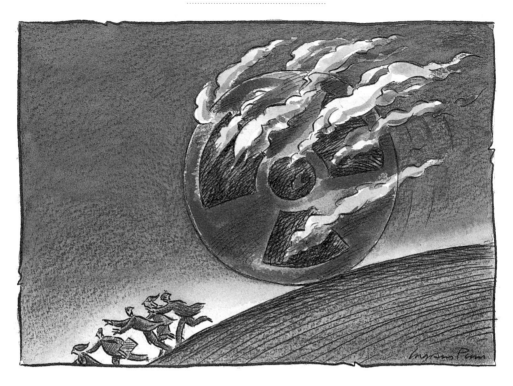

The pyrotechnic meltdown of the Chernobyl-4 nuclear reactor in the Ukraine in the early hours of April 26, 1986 was not, as many in the West assumed, a case of hapless Stalinist technology slouching towards inevitable disaster. On the contrary, Chernobyl-4 was a gleaming new reactor with the best safety record of any in the Soviet Union. Its destruction was brought about by technicians who were trying, ironically enough, to see how the reactor would perform in an emergency. They were so confident of the reactor's robustness that they repeatedly violated its operating manual, ignoring five separate safety warnings that came chattering out of the plant's computer printers before the place blew up.

Following Chernobyl, Western authorities were quick to proclaim that it couldn't happen here, since English, French and American reactors are better built. But the president of the Soviet Academy of Sciences had offered identical reassurances seven years earlier, when the American nuclear reactor at Three Mile Island failed. Both sets of remarks were largely irrelevant, since the error, at both Chernobyl and Three Mile Island, was not mechanical but human.

THE GREENING OF
INTERNATIONAL LAW

The law, it has been said, is a machine that cannot move without crushing someone. One reason for its frightening inertia is that the law relies upon the authority of precedent. It thus stumbles forward while peering backward, upholding traditions even when changing circumstances have rendered them pernicious. The wanton exploitation of nature is such a tradition. Tools, fire, medicine and machinery have brought us dominion over nature, but more of the same won't do. Traditional technology has itself become a gigantic and frightening machine, one that gobbles up resources at one end and befouls the planet at the other, and if permitted to continue without limit it threatens to ruin things for the very species that invented it.

Fortunately there are higher levels of law that can help to guide us away from the dire prospects of runaway technology fueled by shortsighted greed. First there is the law of nature itself – what Einstein called "a spirit vastly superior to that of man, and one in the face of which we with our modest powers must feel humble." Natural laws inform us that we cannot abuse this planet forever and expect it to continue supporting us. The laws of thermodynamics, for instance, reveal that there are limits to the amount of energy we can safely generate on Earth, regardless of how clean the sources of that energy may be. Equally important is moral law, our sense of right and wrong.

Immanuel Kant had both in mind when he said that "two things fill the mind with ever new and increasing wonder and awe, the more often and the more seriously reflection concentrates upon them: the starry heaven above me and the moral law within me." If the machinery of worldly law can be harnessed to both, there will yet be hope for our future on this small world.

GAIA: PLANETARY MEDICINE

In the words of its originator, the British chemist James E. Lovelock, the Gaia hypothesis (named for the Greek goddess of the Earth) maintains "that the entire range of living matter on Earth, from whales to viruses, can be regarded as a single entity, capable of manipulating its environment to suit its needs." This is certainly a provocative idea, one that among many other things suggests that any species that insults the biosphere – us, for instance – may expect to be rejected by it, or to be damped down in something like the way that an oyster isolates an intruding speck of sand by entombing it in a pearl.

But Gaia also leads to talk of "managing" the planet, and if we are to do that we shall have to learn a great many hard lessons, and swiftly. Native Americans, famously integrated with their forest dwellings, were so much a part of it all that they habitually left campfires burning when they quit a campsite and went on their way. If the result was a forest fire, what of it? Forest fires are part of nature, too. Today we manage redwood stands so carefully that detritus on the floor builds up too deep, so that when a fire does occur it burns too intensely, killing trees that would have survived had they endured fires earlier. Saving the planet will of necessity teach us many such tough lessons in harmony.

The losers, if we fail, will not be life on Earth – the biosphere as a whole remains far beyond our powers of destruction – but ourselves. The situation thus harbors a delicious if dangerous symmetry. It implies that we are likely to get exactly what we deserve.

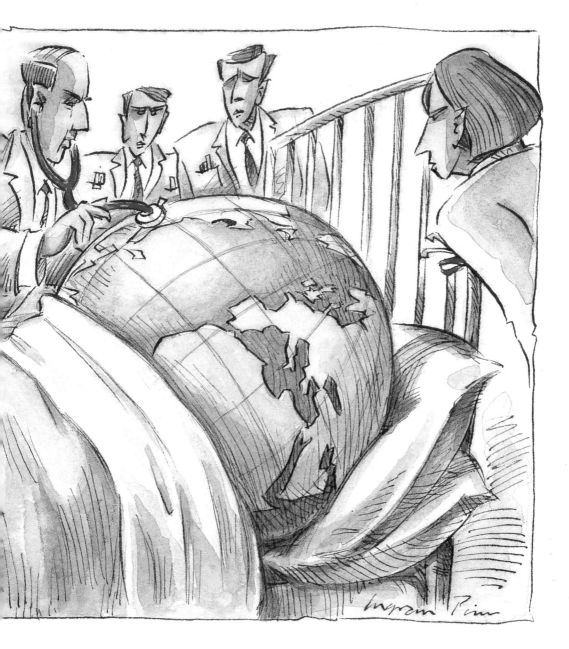

GREENHOUSE EFFECT

"Everybody is doing something about the weather but nobody's talking about it." So said the American environmental scientist John Harte in 1988. Since then there has been more talk about global warming, but no consensus has emerged as to what to do about it.

On one hand we hear dire warnings. Atmospheric levels of carbon dioxide and other greenhouse gases have been increasing throughout the industrial age. CO_2 levels have risen about twenty-five per cent since 1850, and continue to increase. The industrialized nations pump seven billion tons of carbon dioxide into the air annually; each automobile, for instance, dumps its weight in carbon dioxide into the atmosphere each year. Global temperatures have risen nearly one per cent during the same period; a third of that increase came since 1980, during which time we

experienced the three hottest years in this century. Global warming could result in crop failures, rising sea levels due to melting of the Antarctic polar cap, and reduced flow from major watersheds such as the Colorado River, on which Los Angeles depends.

On the other hand, we are reminded that global warming is just a theory and that scientists do not yet have a model of global climate capable of accounting for all its complexities. Some industrial pollutants may offset the effects of others. One such gas is sulfur dioxide, which causes acid rain but also reflects sunlight and thereby helps keep the planet cool. Reducing emissions of greenhouse gases would costs billions; do we want to spend all that money before we are certain it is necessary to do so?

Meanwhile we are conducting a global experiment on the only inhabitable planet in the known Universe. Its outcome is unknown. Its subjects are ourselves.

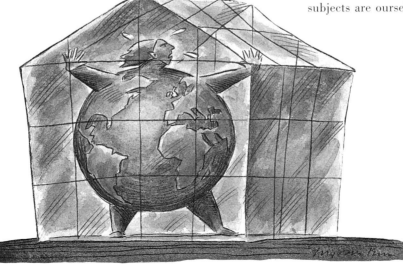

COSTING THE ENVIRONMENT

For most of human history the wilderness was regarded as virtually inexhaustible. Inasmuch as price depends upon scarcity, our economics systems, though capable of pricing board feet of lumber and tons of tuna, have not yet evolved comparable methods of evaluating the wider environment from which these resources are drawn. Not only industrialists but many environmentalists still adhere to this outlook. They insist that the worth, say, of a virgin rainforest or a gin-clear mountain brook is literally incalculable. They tend to favor prohibitory legislation that seeks to defend against pollution and unwise exploitation of nature.

Other environmentalists, however, maintain that it makes more sense to rely upon market forces to achieve the same end. "Prices work wonders," writes the British economist David Pearce. "If polluting products cost more, people will buy fewer of them. If polluting technology costs more, industrialists will switch to cleaner technology." Pearce favors environmental taxes, tradeable permits and other economic incentives "to signal to industrialists, farmers and consumers that pollution does not pay, and pollution prevention does." He thinks it is possible to put a price tag on pollution – he estimates that it currently costs Europe five per cent of its gross national product – and even to quantify the aesthetic "amenity value" of walking in the woods or fishing for pleasure.

Underlying the schism between these two outlooks is an ancient disparity in the way we think about the future. To "deep ecologists" the environmental crisis offers an opportunity to bring about revolutionary changes – redistributing wealth, altering the foundations of religion and philosophy, transforming the entire relationship between humanity and nature. Economists interested in costing the environment are more inclined to assume that human nature won't change all that much. Their debate is reminiscent of the old saying that the optimist believes this is the best of all possible worlds, while the pessimist fears that the optimist may be right.

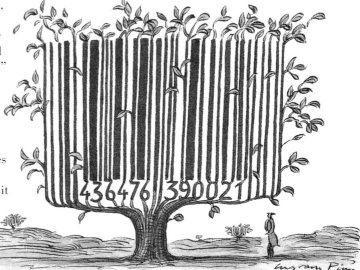

CUTTING POLLUTION

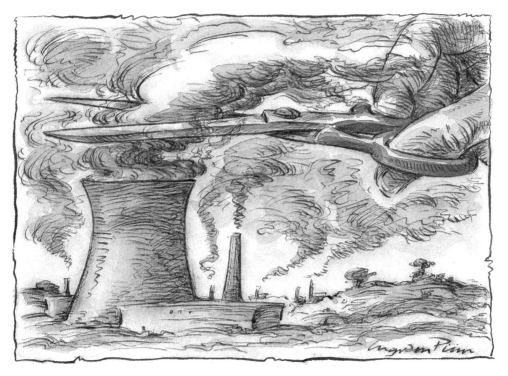

The word "pollution" (from the Latin "to make dirty") means "waste" in both senses. It is not only a description of foul substances, but a synonym for inefficiency. All forms of pollution – the shrieking of subway car wheels, the natural gas burned off in the brilliant banners of flame that adorn petroleum refineries, the heat emitted by nuclear power stations – represent wasted resources. To cut pollution therefore can mean to harvest resources. The amount of heat wasted annually in the United States owing to poor insulation, for instance, exceeds the capacity of the Alaskan oil pipeline, so that in a genuine sense installing thermal glass is equivalent to drilling for oil.

Pollution control, then, is not simply an onerous matter of reconciling ourselves with a degraded lifestyle. It also represents an invitation to make new fortunes. The Japanese government has realized as much, and is inaugurating a one-hundred-year plan to realize industrial profits by devising new ways of cutting pollution.

ECOLOGY OF A GARDEN

The word "Eden" comes from the Hebrew for "happiness." "Paradise" comes from the Persian term for a walled garden. These exercises in etymology suggest that humans have long viewed the delights of nature as involving cultivation and society, not simply untamed nature. Indeed, it is doubtful whether we can conceive of such a thing as "pure" nature, apart from human contemplation of and interaction with it.

It is, of course, vitally important that we preserve those patches of untouched wild that remain on our planet. But if we are, in Johann Wolfgang von Goethe's words, to make "our earthly ball a peopled garden," we shall have to take responsibility for managing the planet properly. To imagine that all would be well if simply left alone is to indulge a Roussean fantasy of a world that never was.

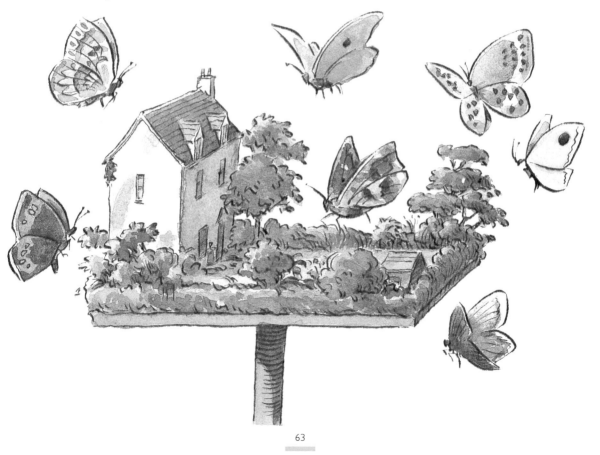

TASTING
FORBIDDEN FRUIT

The Faust myth – which warns that science can go "too far" – enjoys a cultural status comparable to that of the Oedipus myth, and the more technology develops the more important it becomes. No new technology invokes Faust more forcefully than does genetic engineering. Scientists in the field can sense that solutions to major problems, from starvation to crippling birth defects, lie almost within their grasp. Opponents fear that in tinkering with DNA, the coded essence of life, science may unleash dark forces that it cannot thereafter contain. While it is tempting to dismiss such cries of alarm, couched as they so often are in an inferior grasp of the technicalities, the conflict cannot be resolved simply by heeding the reassurances of experts. As Niels Bohr remarked, an expert is someone who has made all the major mistakes in his field. We can hardly expect the public to permit many mistakes in a field that aims to alter the skein of life upon which our existence depends.

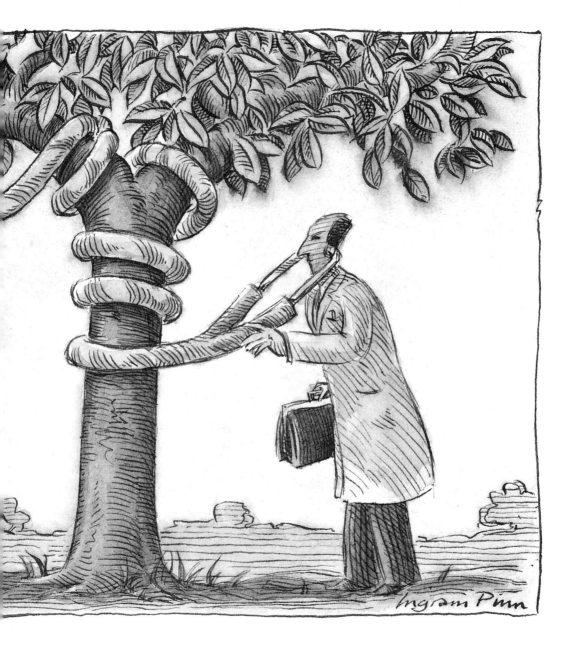

Part Four

SCIENTISTS AND SOCIETY

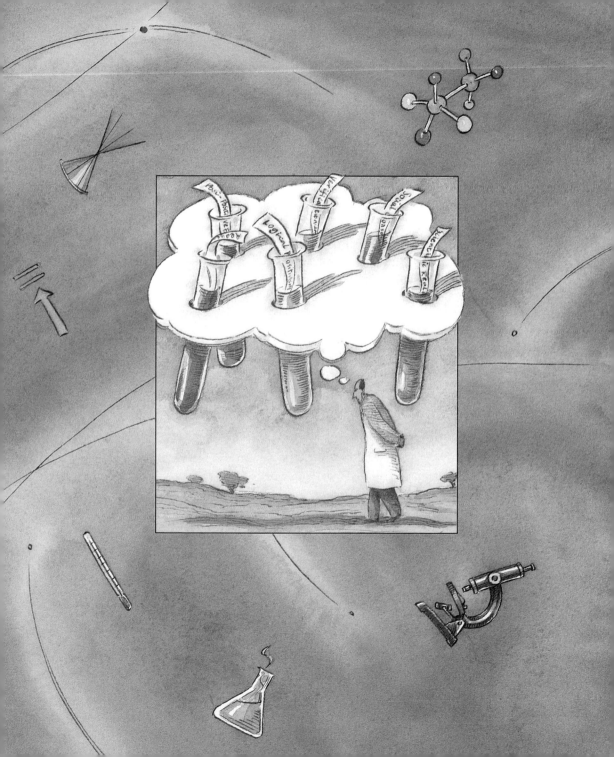

ISLAMIC SCIENCE

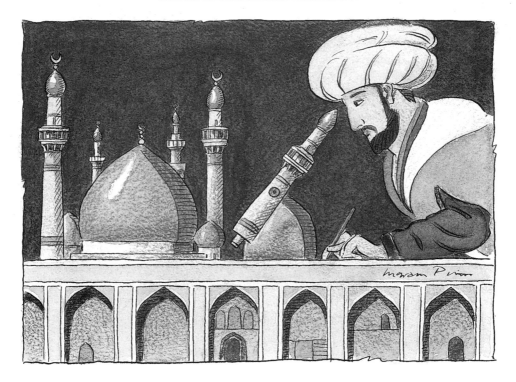

From the seventh to the thirteenth century, in centers of learning from the Persian Gulf to Syria across northern Africa to Spain, Islamic scholars advanced the sciences of physics, astronomy, chemistry, medicine and geography. It was in the Islamic world that chemists like Abu Musa Jabir ibn Haiyan studied the specific gravity of precious metals, the physicist Ibn al Haitham ground parabolic mirrors and studied atmospheric refraction, and mathematicians developed algebra, itself an Arabic word. (One of the ablest of the mathematicians

was the poet Omar Khayyam.)

Too little of this chapter in the history of science appears in western schoolbooks, but you can read it in any star chart. The names of northern hemisphere constellations are mostly Greek, while the names of the stars are mostly Arabic. Often the Arabic comments on the Greek. The brighter stars of the Greek-named constellation Ursa Major are named Dubhe, Merak, Phecda, Megrez, Alioth, Alcor, Mizar, and Alkaid - a spray of Arabic poetry describing the big bear's back, loins, thighs and tail.

GALILEO GALILEI
(1564–1642)

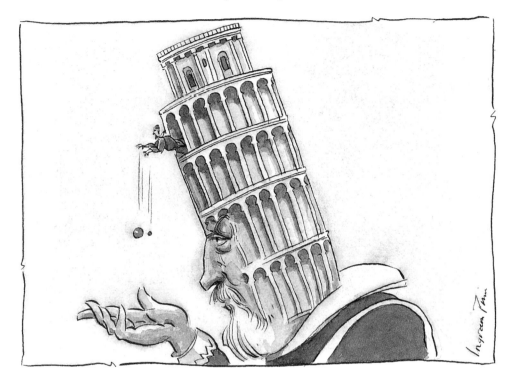

Galileo probably never performed his most famous experiment, the one that involved dropping two balls of unequal weight from the Leaning Tower of Pisa to demonstrate that all objects, regardless of weight, fall at the same velocity in a vacuum. The experiment would not have worked: the tower stands not in a vacuum but in the humid air of the coastal plain of Tuscany and, owing to air resistance, the heavier ball would have hit the ground first. Galileo minimized this effect by experimenting with balls rolling down inclined planes, and also relied upon the verdict of a thought experiment that brought him to the correct conclusion. In a sense the myth conveys a truth – that Galileo was one of those rare thinkers who can arrive at the right answer even when the experimental data are misleading.

MICHAEL FARADAY
(1791–1867)

One day the chemist Sir Humphry Davy received a custom-printed, leather-bound set of notes on a public lecture he'd recently given. Sir Humphry was surprised to learn that the sumptuous gift came not from a fellow scholar but from an unschooled apprentice to a London bookbinder, who had educated himself by reading every science book he could get his hands on. Impressed, he hired the young Michael Faraday as a laboratory assistant at the Royal Institution of Great Britain.

There Faraday remained for the next forty-six years, conducting more than fifteen thousand experiments. He found that electricity and magnetism are conveyed by means of invisible fields that can be traced out by sprinkling iron filings on a paper resting on a horseshoe magnet. Such was the birth of the field concept, today employed in physics equations that the innumerate Faraday could not have hoped to comprehend. "Would Faraday have discovered the law of electromagnetic induction if he had received a regular college education?" This question was posed by Einstein, a virtuoso of field theory and enemy of what he called the "dull specialization that stares with self-conceit through horn-rimmed glasses and destroys poetry." The answer, in Einstein's opinion, was no.

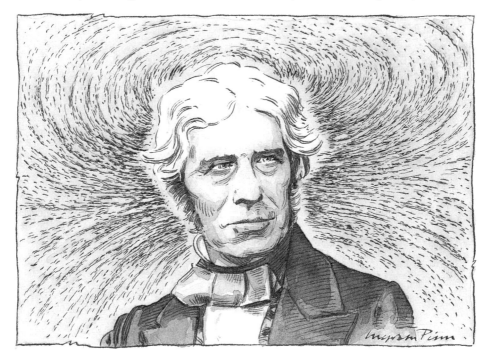

CHARLES BABBAGE
(1791–1871)

The irascibility of the mathematical genius Charles Babbage reminds us that many of the scientists we today revere as grey eminences were firebrands and oddballs in their creative years. Scornful of tradition, Babbage infuriated and bewildered his elders. A monograph he and fellow students at Cambridge wrote espousing a reform in mathematical notation – it involved replacing the dots employed in Newtonian calculus with the "d" used by Leibnitz – was titled *The Principles of pure D-ism in opposition to the Dot-age of the University.* Fascinated by heat, Babbage had himself baked in an oven at 265°F for "five or six minutes without any great discomfort." His hatred of noise was comparable to Arthur Schopenhauer's, and led him to campaign against organ grinders; irritated neighbors responded by paying street musicians to play outside his window.

This cranky thinker invented the speedometer, the locomotive cowcatcher, lighthouses that flash in code – and the Difference Engine, a working mechanical computer. He planned a larger computer but the British government, chary of his reputation, eventually suspended his funding. Babbage's death went mostly unremarked, save for a few lines in *The Times* making fun of him. Only recently has interest revived in his notion that the Universe can be viewed as a computer.

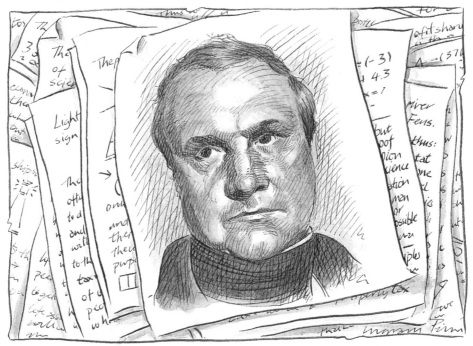

CHARLES LYELL

(1797–1875)

The practice of science, like the writing of novels, begins with a penchant for detail. Myopia may help, by encouraging a disposition toward scrutiny. Charles Lyell was near-sighted. During holiday trips to the seashore as a student he noticed, as other bathers had not, that erosion was gradually altering the shape of the coastline near Norwich, East Anglia. He began to conceive of the planet as a seething, changing entity, writhing like a living organism. For the rest of his life he trod the landscape, finding evidence of change everywhere from Mount Etna to the Chilean Andes. Biblical catastrophes, he argued, were not required to transform the Earth; imperceptibly slow alterations would suffice. "The causes which produced the former revolutions of the globe," he wrote, were the same as "those now in everyday operation." All that was required was that the Earth be many millions of years old. Among his readers was the young Charles Darwin, who packed a copy of Lyell's *Principles of Geology* in his trunk and then set sail aboard the *Beagle*.

CHARLES DARWIN

(1809–1882)

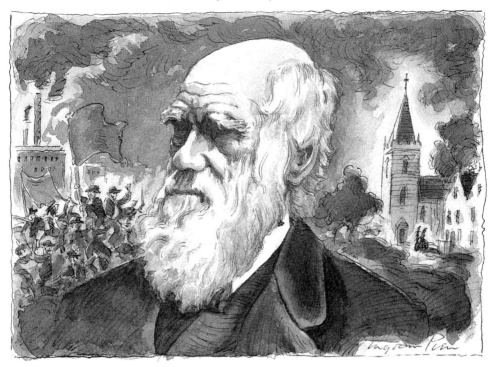

Though we may find much to agree with in the philosopher Ludwig Wittgenstein's condemnation of the worship of science and the lionization of scientists, still there is a lot to admire in the scientific point of view and in the character of many leading scientists.

Consider Charles Darwin. He was unsentimental enough to formulate a theory of evolution as revolutionary as any that has yet upset this world, even though he owned an enormously warm-hearted love of nature. "I fell fast asleep on the grass," he wrote his wife in 1858, "and awoke with a chorus of birds singing around me, and squirrels running up the trees, and some woodpeckers laughing, and it was as pleasant and rural a scene as ever I saw, and I did not care one penny how any of the beasts or birds had been formed." Acclaimed as a genius and excoriated as an atheist, Darwin neither rested on his authority nor permitted himself to react angrily to attacks from the forces of religious fundamentalism. "We are confessedly ignorant; nor do we know how ignorant we are," he wrote.

If such a man is not to be emulated, who is? And if science is not the discipline that most often promotes and rewards such exemplary qualities, what is?

ALFRED RUSSEL WALLACE

(1823–1913)

Great scientists tend to take a keener than normal interest in fields outside their areas of specialization. Fame amplifies this tendency; one newly minted Nobel laureate joked that "since I got the prize I'm expected to be an expert on everything." Alfred Russel Wallace discovered, independently of Darwin, how species originate through natural selection. He carried eclecticism to excess lending his authority to such dubious causes as spiritualism and the belief that fairies may be found supping on dewdrops in Irish meadows at dawn. But it is hard to fault his relentless curiosity and open-mindedness. As Einstein remarked, "Death alone can save one from making blunders."

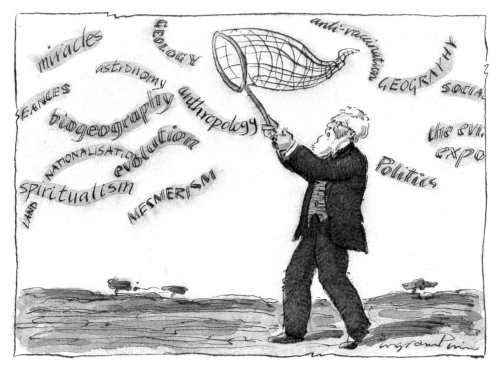

LISE MEITNER
(1878–1968)

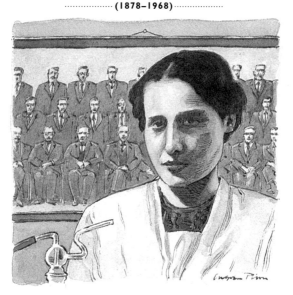

On Christmas Eve of the ominous year 1938, two physicists, Lise Meitner and her nephew Otto Frisch, strolled through the snowy streets of the Swedish village of Kungälv, talking intently about how uranium atoms might be split. Meitner, a Jewish refugee from Nazi Germany, had just learned from a friend and colleague in Berlin, Otto Hahn, that uranium when bombarded with neutrons produced the light element barium. Hahn was stumped, but Meitner, a skilled mathematician with a canny grasp of nuclear physics, found the answer. Talking with her nephew that night, she realized that Hahn was splitting uranium nuclei, thus producing barium and releasing energy.

Back in Copenhagen after the holidays, Frisch told Niels Bohr, who at once grasped the validity of Meitner's reasoning. "Oh what idiots we have all been!" Bohr exclaimed. "Oh but this is wonderful! This is just as it must be!"

Although Meitner tried to keep her theory quiet until she could publish it, word spread quickly. Within a month, physicists in American laboratories were performing experiments confirming her claim that "nuclear fission," as she and Frisch called it, could liberate vast quantities of energy. Only a week after that, in Berkeley, California, the office of professor Robert Oppenheimer was adorned by a crude blackboard drawing of a fission bomb. "It was an unfortunate accident that this discovery came about in time of war," said Meitner, years later. "I myself have not worked on smashing the atom with the idea of producing death-dealing weapons."

Hahn was awarded the Nobel Prize and Meitner was not.

NIELS BOHR
(1885–1962)

Twentieth-century physics was graced by the presence of two
towering geniuses, whose characters were as exemplary as their
intellects. One, of course, was Einstein, his masterpiece
relativity, his province the far reaches of cosmic space. The
other was Niels Bohr.

Bohr worked in quantum theory, the science of the subatomic
realm. He received the Nobel Prize for his work in deciphering
the structure of the atom and linking it to the periodic table of
the elements. In addition he was an exemplary mentor, teacher
and critic, who drew leading physicists from around the world to
his native Copenhagen and there had a hand in some of the most
revolutionary developments in quantum theory.

Notable among these was the realization that matter and
energy can be viewed as both particles and waves, even though
particles and waves have mutually exclusive properties. To make
sense of this seeming paradox, Bohr – who like Einstein was a
philosopher as well as a scientist – developed a view he called
"complementarity." From a complementarian standpoint we
cease to insist that an electron, say, must be either particle or
wave, and accept that it looks like one or the other depending
upon the perspective from which it is investigated. The
American physicist John Archibald Wheeler encapsulated
complementarity by quoting an eighteenth-century thinker, the
Abbe of Galiana: "One cannot bow in front of somebody without
showing one's back to somebody else."

Universally described by those who knew him as one of the
kindest and gentlest of men, Bohr applied the principle of
complementarity to nonscientific questions such as the duality
between clarity and accuracy in communication – "Never express
yourself more clearly than you think," he used to say – and the
quest for peace among nations, which, he argued, could be
increased if each nation tried harder to appreciate both its own
and its adversary's true points of view. Einstein, who hotly
disputed with Bohr about many of his scientific views, always
held him in the highest esteem, calling him "a highly gifted and
excellent man," and adding, "It is a good omen for physics that
prominent physicists are mostly also splendid people."

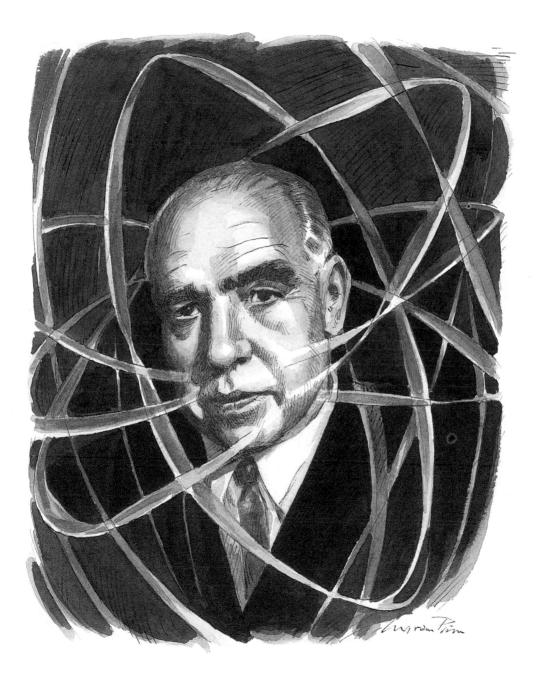

The sciences began as a man's activity in a man's world, and remain mostly male today. Sexist attitudes are especially widespread in "hard" sciences like physics. The physicist Alma Norovsky recalls that while attending a conference "I was standing with a group of physicists, all men, and I was introduced to a new member of the group. He said, 'You're the first good-looking physicist I've ever met.' I casually indicated the man standing beside me and said, 'Oh, that's not true. You know Richard here. He's good looking, and he's a physicist."

Although growing numbers of women are to be found in the physical sciences, progress has been painstakingly slow. In the United States there was widespread outcry when in 1991 the National Academy of Science elected only five female scientists among its sixty new members; the following year the Academy elected fifty-nine new members, and once again only five were women. The unwelcome result of this sort of inertia is that most sciences continue to recruit from only half the brain power of the human species.

SCIENTIFIC INTELLIGENCE SERVICE

When scientists are recruited into military endeavors, the ultimate outcome is seldom a happy one. The English mathematician Alan Turing cracked the German Enigma code, a signal contribution to Allied victory in the North Atlantic, only to be hounded to suicide by the government's anti-homosexuality laws in the postwar years. The American physicist Oppenheimer, having headed the Manhattan Project that resulted in the atomic bomb, was rewarded with the public disgrace of having his loyalty questioned and his security clearance revoked.

But if the term "military intelligence" is to be regarded as an oxymoron, the reasons have to do not with individuals – there are, after all, plenty of intelligent people in the military – but with institutions. Science is inherently open and egalitarian, and thrives on free speech; the military is inherently closed, hierarchical and secretive. And that may be why the long-term employment of great numbers of scientists in classified military research, a legacy of the Cold War, has yielded less benefit to either science or the military than government leaders had hoped would be the case.

SCIENTIFIC REASONING

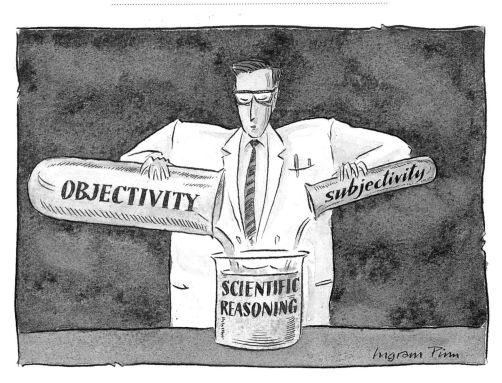

Objectivity dominates the mix in this illustration for two reasons. First, experimental data must be analyzed with a reasonable degree of objectivity; a scientist cannot recklessly ignore everything that conflicts with a favored hypothesis.

Second, the finished paper must aspire to stand up to objective scrutiny; its conclusions should be judged as supportable by qualified researchers other than the author.

But subjectivity is important, too, for it is here that creativity enters the picture, and good science is as creative as good art. Scientists in designing an experiment or concocting a theory are not just weighing the evidence, but are trying to establish that nature is the way he or she *thinks* it is, or ought to be. Objective criteria set the height of the net and describe the boundaries of the court, but it is the passion of the subjective idea that strikes the ball.

Embryology / Origami

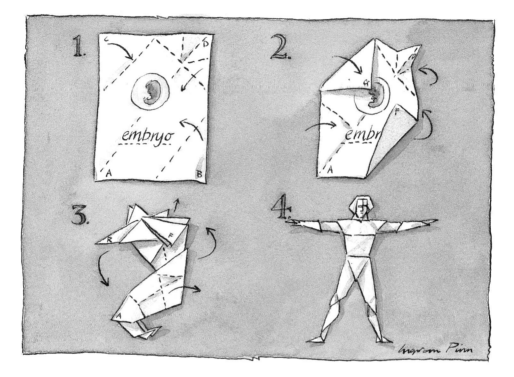

Insofar as ontogeny recapitulates phylogeny, the development of the embryo involves considerable waste. Gills are fashioned only to disappear, and most of the brain cells each of us will lose throughout our lives are killed off while we are still in the womb – because the only way the embryo knows to build a human is to first assemble, then largely disassemble, pieces of the ancestral creatures that preceded us. But embryology also displays breathtaking precision. (The arms, for instance, grow for some fifteen years without consulting each other, yet wind up the same length.) How does nature manage it? In part, it seems, by following coded instructions a lot like the ones found in directions for making paper airplanes: fold here, bend there, insert tab A into slot B. Folding is also involved in the way that proteins make strings of amino acids into enzymes. Something there is in nature that loves a fold.

GYROSCOPIC ATTRACTION

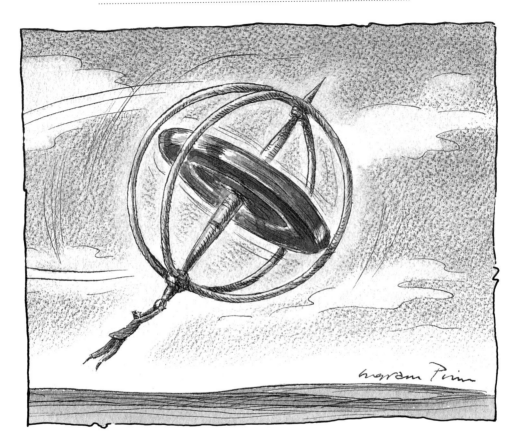

A spinning gyroscope is true not to the spinning Earth but to the distant stars. The resistance you feel when you tug at one is in a sense generated by the entire Universe. Newton was one of the few to marvel at this simple fact. The Austrian physicist Ernst Mach was another. Mach called attention to what today is called the "Machian framework" of the Universe as a whole – the fact that the distribution of matter across the cosmos somehow dictates the behavior of gyroscopes and whirling buckets of water, though exactly how it does so remains a mystery. Einstein tried (unsuccessfully) to incorporate Mach's realization into relativity, and today we still do not fully understand how it is that inertia links the Earth to the wider cosmos. Theorists hope that a quantum account of gravity will show the way to an answer. Meanwhile every gyroscope mocks our ignorance.

COLD FUSION

The cold fusion fiasco was florid with violations of protocol, and as such provided the world with an excellent example of what scientific ethics are for. The first offense came at the outset. When, in a hastily called press conference on March 23, 1989, two chemists announced that they had discovered an abundant form of free energy, they were violating an embargo agreed upon with colleagues at a rival university who were working in the same field. Furthermore they produced no paper supporting their claims, but asked that the news be accepted on their personal authority. (Their paper was soon rejected by the journal to which they had submitted it.) Then, when scientists attempting to reproduce the alleged results asked to be provided with essential details of the experiment, the chemists refused, citing the advice of their patent attorneys.

Now that the cold fusion balloon has deflated, the chemists have become a laughing stock. Their transgression was not that they were wrong – that can happen to anybody – but that they subordinated the ethics of their profession to the lure of fame and fortune. The fundamental verities still applied, even in the white heat of the go-go 1980s. That lesson may be worth more than fusion in a jar.

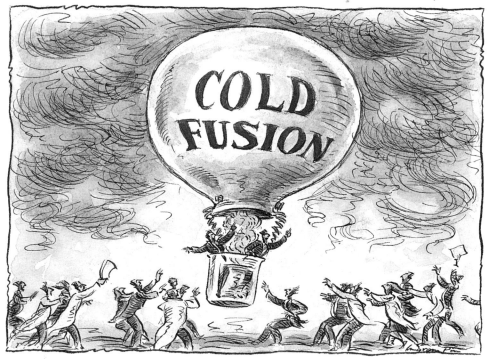

SCIENTIFIC GENIUS

Might chance, the key to creativity in biological evolution, play a creative role in human thought? The psychologist William James thought so. In 1880 he proposed a Darwinian model of original thought. "New conceptions, emotions, and active tendencies which evolve," he wrote, "are originally produced in the shape of random images, fancies, accidental outbursts of spontaneous variation in the functional activity of the excessively unstable human brain." Many cognitive scientists today agree. They suggest that a kind of high-speed Darwinism takes place in the neocortex – a process in which original ideas crop up at random and then survive or fail in microseconds, depending upon their fitness for rapidly-changing electrochemical environments produced by surrounding brain activity. Viewed by such lights, the old question of whether the intricate beauty of biological systems could have been produced by mere chance is turned on its head, and we are prompted to ask whether design could have done as good a job as chance evidently has.

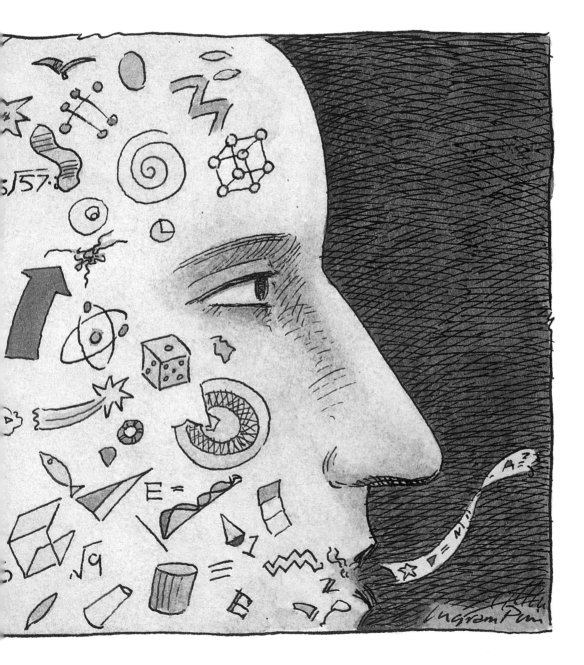

NEWTON ON THE SEASHORE

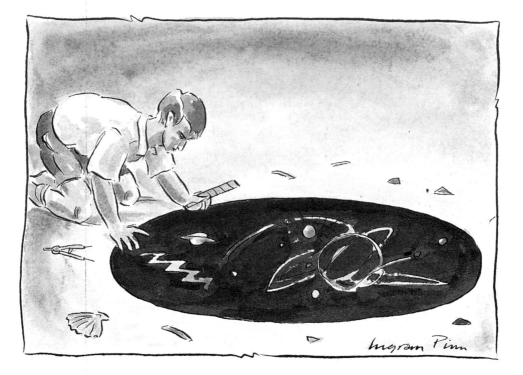

Tiny is the island of the known, boundless the ocean of what remains to be learned. This may be what Newton meant when he declared, "I do not know what I may appear to the world; but to myself I seem to have been only like a boy playing on the seashore, and diverting myself in now and then finding a smoother pebble or a prettier shell than ordinary, whilst the great ocean of truth lay all undiscovered before me." He was not trying to be modest (a lost cause in Newton's case anyway) but was out to convey what the American physician Lewis Thomas called "the greatest of all the accomplishments of twentieth-century science ... the discovery of human ignorance."

Stephen Hawking, upon assuming Newton's old post as Lucasian professor of mathematics at Cambridge, wondered aloud whether attainment of an ultimate unified theory of particle interactions would spell the end of physics. Hawking later confessed that he'd only been trying to say something provocative, but in any event an end to physics would but only mark the opening of a new chapter in human enquiry. The brightest of the pebbles we have gathered are the ones that reflect the wide dark sea.

RELIGION AND SCIENCE

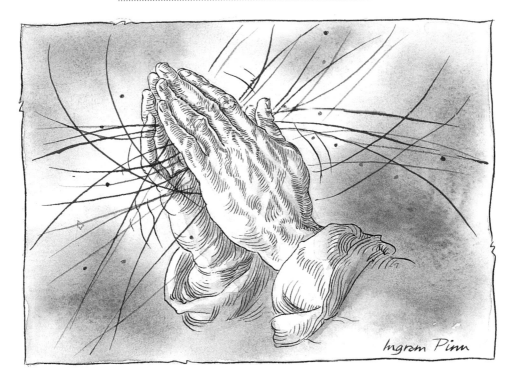

Many well-intentioned thinkers have sought to reconcile science and religion. As their excellent efforts generally have failed, perhaps it's time to take a fresh perspective on the question. We value variety in, say, art and biology. Nobody thinks the world would be better if Edouard Manet were more like Mark Rothko, or fish like fowl. It might be refreshing to assume a similar attitude towards science and religion – to let them go their separate ways, rather than striving to bring them together under the roof of a single, monolithic structure.

To do so would be to heed the council of a wise elder, the English historian of science Joseph Needham. Interviewed on the occasion of his ninety-first birthday, Needham recalled that since his youth he had embraced the view of the Oxford scholar R. G. Collingwood, who identified religion, science, history, philosophy and aesthetics as the five essential but mutually exclusive forms of human experience. "If you are tone deaf to one of them, you are in trouble," Needham said. But, he added, "I don't think there is any necessity to reconcile them."

ENDNOTES

page 27 J. Richard Gott III, conversation with Timothy Ferris, Irvine, California, 27 March 1992.

34 Francis Crick, *What Mad Pursuit: A Personal View of Scientific Discovery*, (Basic Books, New York, 1988), p. 79.

36 Isaac Newton, *Optics*, Book 3, Part 1, in *Great Books of the Western World*, ed.Robert Maynard Hutchins, XXXIV, p. 542.

38 Lawrence Le Shan and Jerry Margenau, Einstein's Space and Van Gogh's Sky, (MacMillan, New York, 1982), p. 51.

38 Eugene Paul Wigner, "The Unreasonable Effectiveness of Mathematics in the Natural Sciences," *Communications in Pure and Applied Mathematics*, 13 (1960), pp 1–4.

48 Philip J. Hilts, *Scientific Temperaments* (Simon & Schuster, New York, 1982), p. 51.

57 *Albert Einstein, The Human Side: New Glimpses From His Archives*, selected and edited by Helen Dukas and Banesh Hoffmann, (Princeton University Press, New Jersey, 1979), pp. 32–33.

57 Immanuel Kant, *Critiques of Practical Reason*.

58 James E. Lovelock, "Elements" in *Gaia: An Atlas of Planet Management*, ed. Norman Myers, (Anchor Books, New York, 1984), p.100.

61 David Pearce, "Is the Public Ready to Pay the Price?" in *The Times* (London, 26 September 1990).

60 John Harte, Lecture at the University of California, Berkeley, 15 November 1988.

68 For a survey of Islamic science, see George Sarton, *Introduction to the History of Science* (Williams & Wilkins, Baltimore, 1927, 1931; and Seyyed Hossein Nasr, *An Introduction to Islamic Cosmological Doctrines*, (Dent, London, 1932).

70 Albert Einstein, *Ideas and Opinions* translated by Sonja Bargmann (Dell, New York, 1979), p. 344.

70 *Albert Einstein, The Human Side: New Glimpses From His Archives*, eds. Helen Dukas and Banesh Hoffmann (Princeton, New Jersey, Princeton University Press, 1979), p.99.

72 *Masterworks of Science*, ed. John Warren Knedler (New York, McGraw-Hill, 1973), p. 55.

73 Gavin DeBeer, Charles Darwin, *Evolution by Natural Selection*, (Doubleday, Garden City, New York, 1964), p. 148.

73 Stephen Toulmin and June Goodfield, *The Discovery of Time*, (University of Chicago Press, 1982), p. 222.

74 Max Born, *The Born-Einstein Letters*, (Walker, New York, 1971), p. 220.

76 John Archibald Wheeler, Address at ceremony conferring the Atoms for Peace Award on Niels Bohr, 1957.

76 Abraham, Pais, *Niels Bohr's Times*, (Clarendon Press, Oxford, 1991), p. 220.

79 Vivian Gornick, "Women in Science," in *Women in Science: Portraits From a World in Transition*, ed. Vivian Gornick (Simon & Schuster, New York, 1983), p. 89.

84 Morton Schatzman, "A Psychology of Science," *New Scientist*, 6 May 1989, p. 58.

86 David Brewster, *Memoirs of the Life, Writings and Discoveries of Sir Isaac Newton*, (T. Constable, Edinburgh, 1855) II, chapter 27.

86 Lewis Thomas, "Debating the Unknowable," *The Atlantic Monthly*, July, 1981.

87 Arguerite Holloway, "The Builder of Bridges," *Scientific American*, May 1992, p.56.